Coloring Supplies

There are so many great things about coloring, but the very best part has to be the art materials! Colored pencils, markers, watercolors, gel pens, puffy pens, crayons—there are so many exciting materials to try. There's no better feeling than getting comfy in your favorite spot with a coloring book and a rainbow assortment of beautiful markers (or gel pens, or watercolors, or freshly sharpened colored pencils!) in front of you. Choose materials and colors that reflect how you're feeling. Colored pencils are delicate and markers are bold. Whatever mood you're in, go with it and have fun on your coloring adventure. Consider mixing two or three different mediums in the same design to create your own unique effects. Anything is possible on the page!

Watercolors

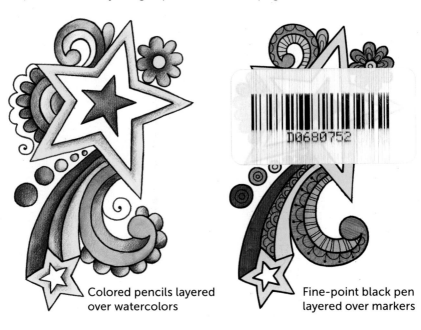

Colored pencils layered over watercolors

Fine-point black pen layered over markers

Express Yourself with Color

Color can be a great way to express yourself and define your mood. When you sit down to color, ask yourself, "How can I use color to express the way I'm feeling?" Sometimes you might even feel something you can't quite put into words, but you can express it with color.

On the opposite page, I've included 20 of my favorite palettes. Each one is paired with the emotion that best describes how the color combination makes me feel. But keep in mind that everyone is different, and that's what makes art so exciting. I love to use bright colors, but maybe you like more subdued colors. My "relaxed" palette might be your "cozy." There is no right or wrong when it comes to color!

Use these palettes as a starting point and see how they make you feel. Try customizing the palette to reflect your taste and style by adding or taking away a color. Then, make your own page full of your favorite color palettes.

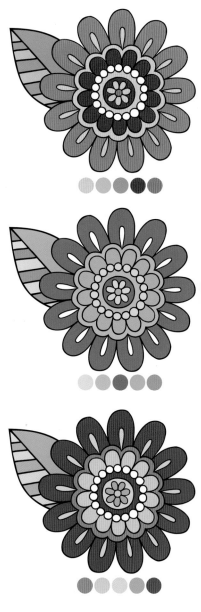

Notice how changing the color palette gives the same flower a completely different feel.

A Spectrum of Emotion

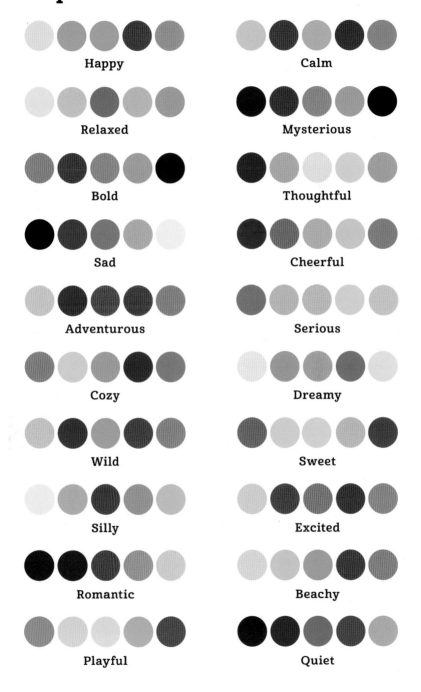

Happy

Calm

Relaxed

Mysterious

Bold

Thoughtful

Sad

Cheerful

Adventurous

Serious

Cozy

Dreamy

Wild

Sweet

Silly

Excited

Romantic

Beachy

Playful

Quiet

How to Use the Color Palettes

You'll see two color palettes on each colored example page, one at the bottom and one along the outer edge. The palette at the bottom shows the design's main colors in the large circles. The small circles show lighter colors (called tints) and darker colors (called shades) of those main colors. This is to give you the feeling of the palette and visually show which colors are dominant in the design (the bigger the circle, the more dominant the color).

Along the outer edge of each page, I've included a palette with each individual color shown separately so you can easily match your marker, pencil, or paint colors to the colors I used.

Whether you use one of my palettes or create your own, always be sure the colors you choose reflect who you are and how you're feeling. Have fun on your coloring adventure!

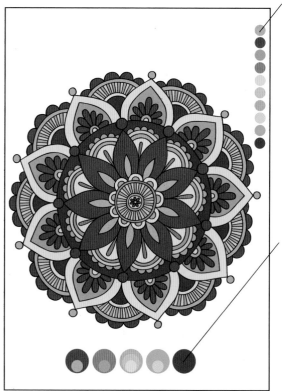

The circles along the outer edge of the gallery pieces show you each individual color I used in that particular piece. If you like the palette I chose, you can use these circles to match the colors of your own pencils or markers.

The circles along the bottom of the gallery pieces show you which colors are more dominant in each design. The larger the circle, the more dominant the color. The smaller circles show tints and shades of a main color that were introduced for variety.

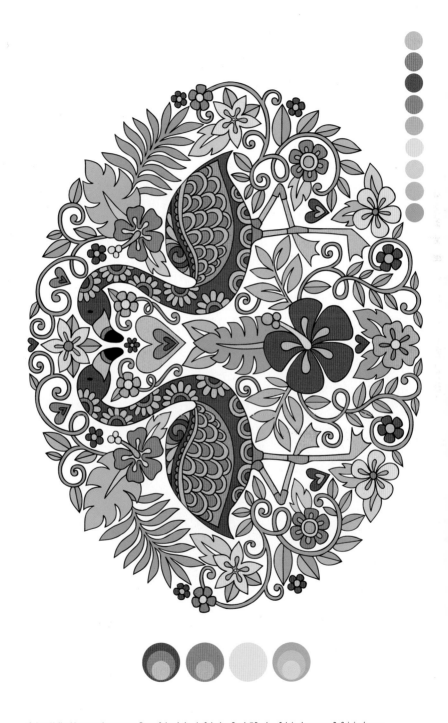

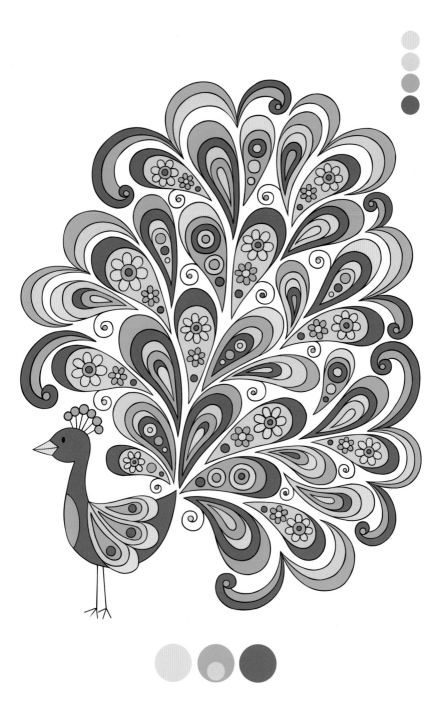

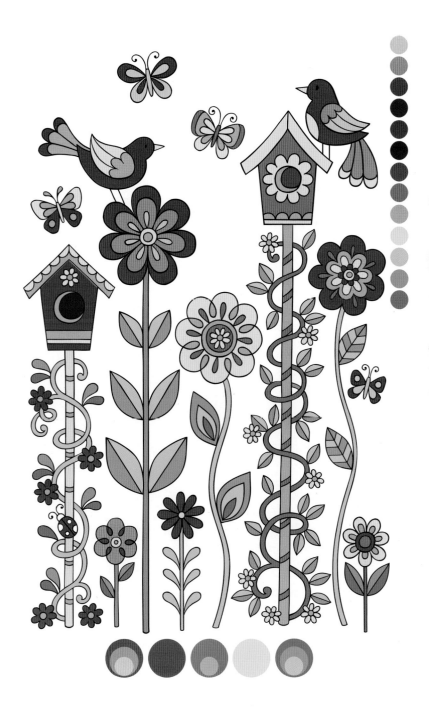

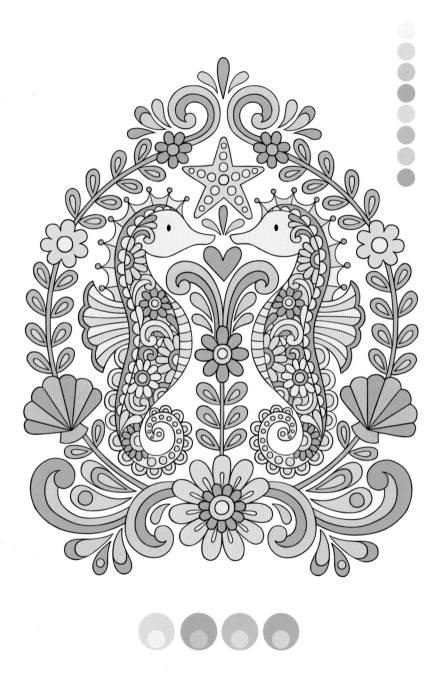

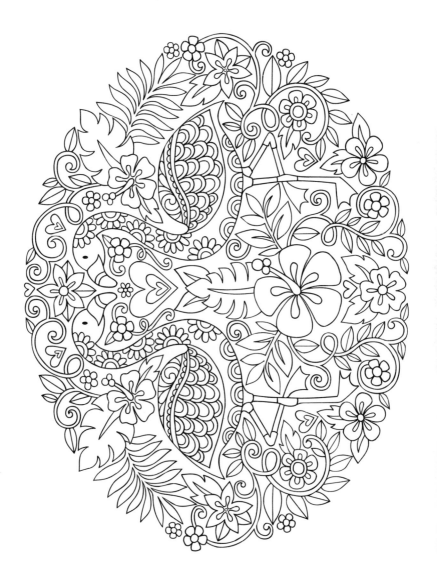

The best way to cheer yourself up
is to try to cheer someone else up.

—Mark Twain

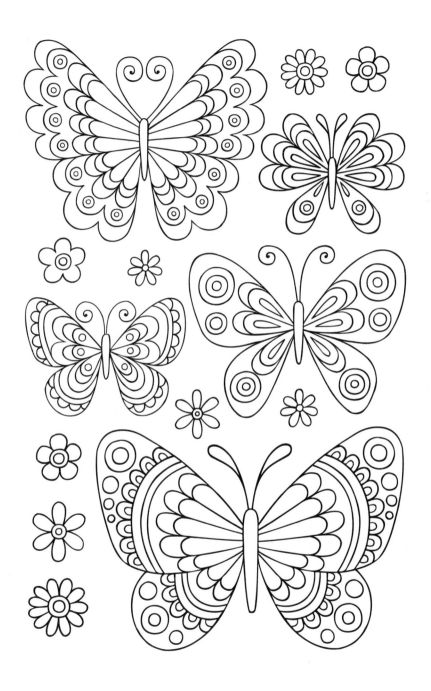

Let us be grateful to people who make us happy;
they are the charming gardeners
who make our souls blossom.

—Marcel Proust

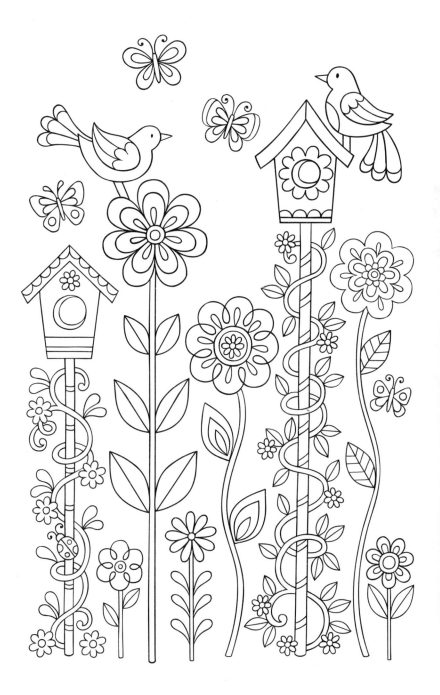

Rapidly, merrily,
Life's sunny hours flit by,
Gratefully, cheerily,
Enjoy them as they fly!

—Charlotte Brontë, *Life*

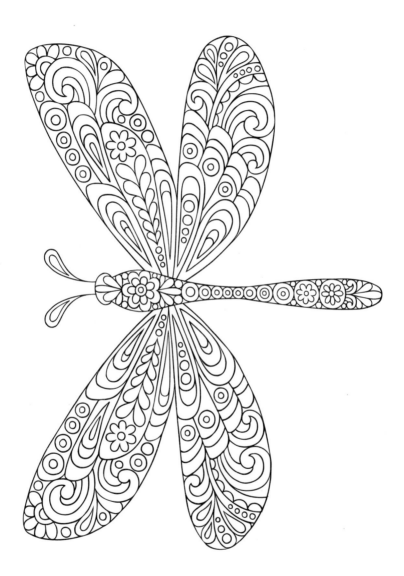

There are so many beautiful
reasons to be happy.

—Unknown

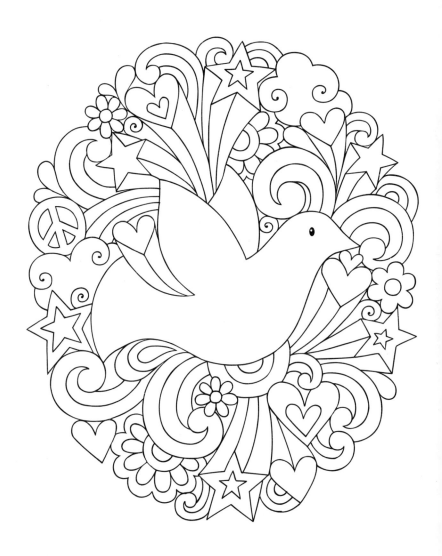

Hold hands, not grudges.

—Unknown

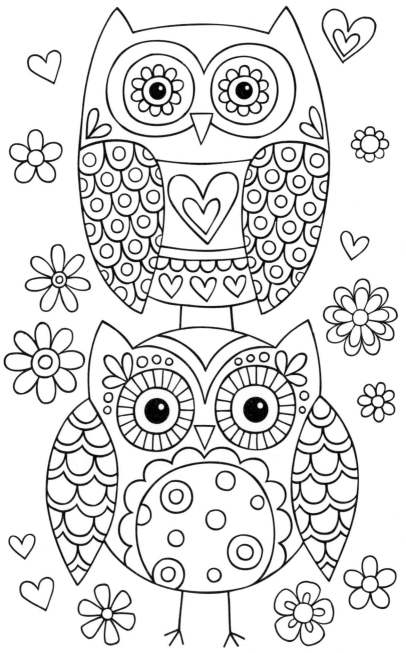

The greatest good
is what we do for one another.

—Mother Teresa

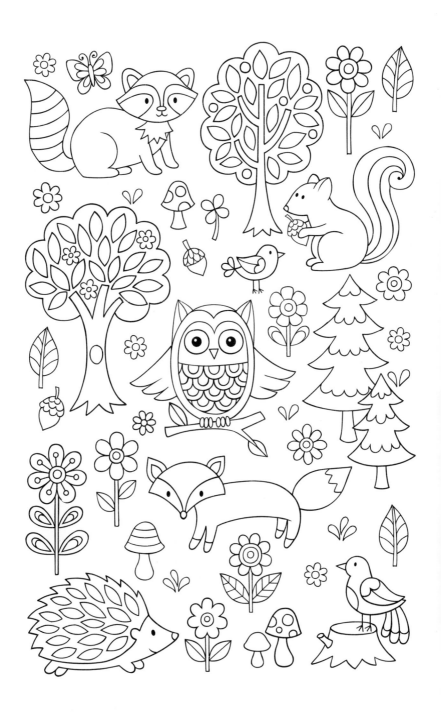

No act of kindness, no matter how small,
is ever wasted.

—"The Lion and the Mouse," *Aesop's Fables*

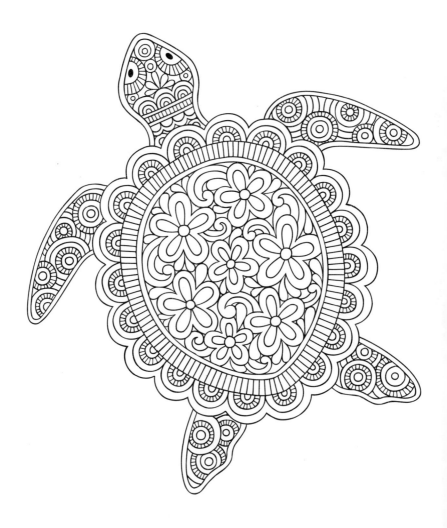

How beautiful a day can be
when kindness touches it!

—George Elliston

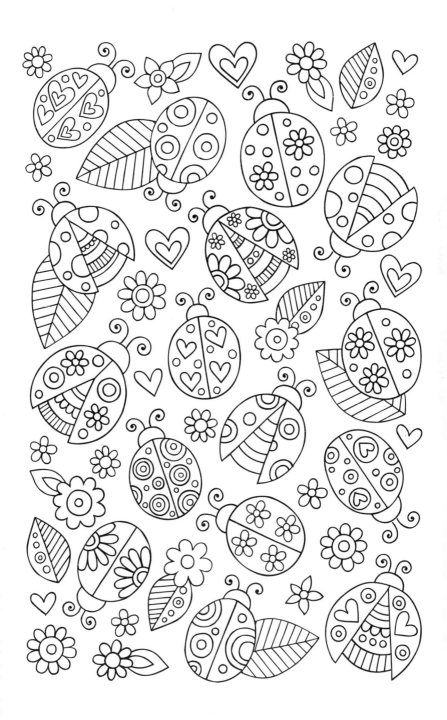

Happiness often sneaks in through a door
you didn't know you left open.

—John Barrymore

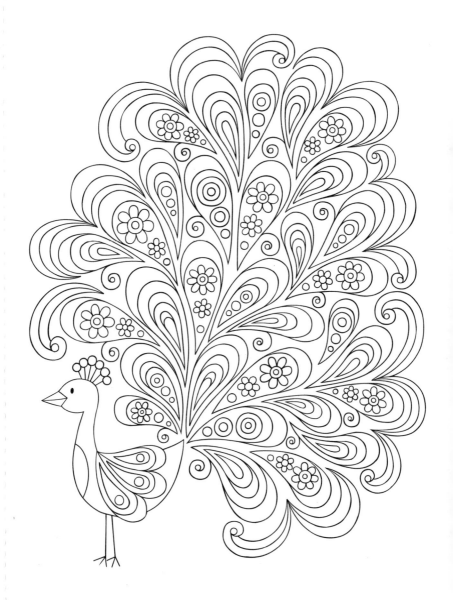

The best things in life are silly.

—Scott Adams

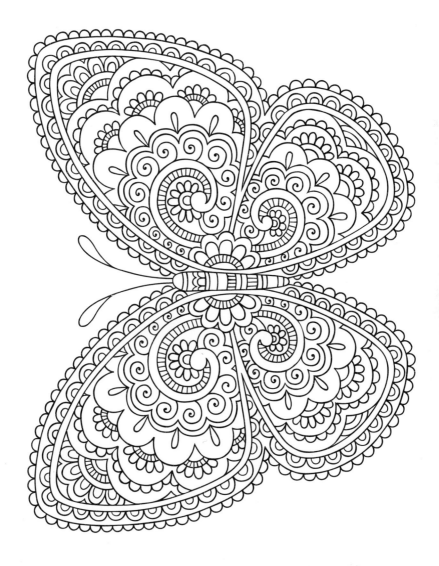

Remember that your natural state is joy.

—Wayne Dyer

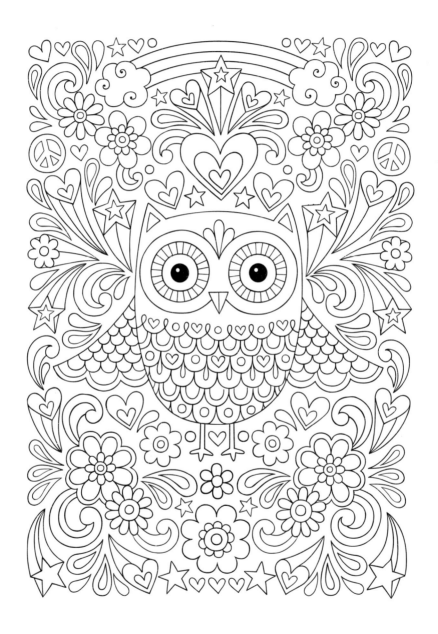

If you want to be happy, be.

—Leo Tolstoy

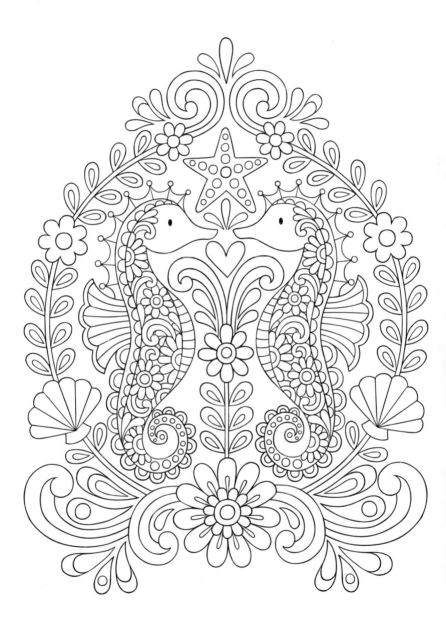

Laughter is the shortest distance
between two people.

—Victor Borge

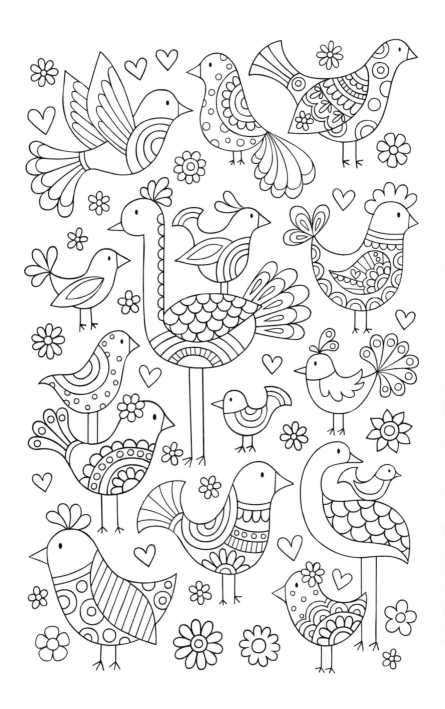

Happiness seems made to be shared.

—Pierre Corneille

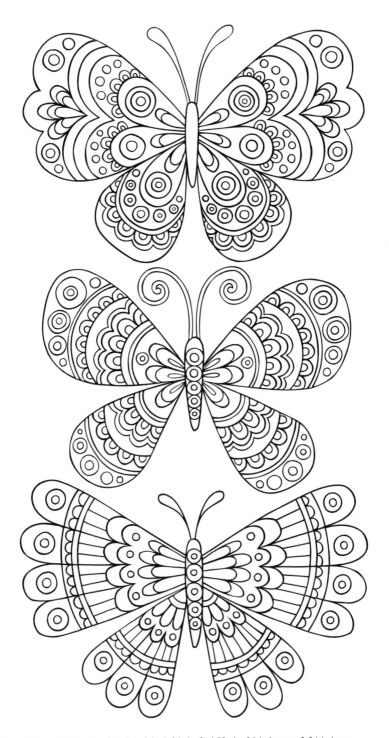

Those who bring sunshine to the lives of others
cannot keep it from themselves.

—J. M. Barrie

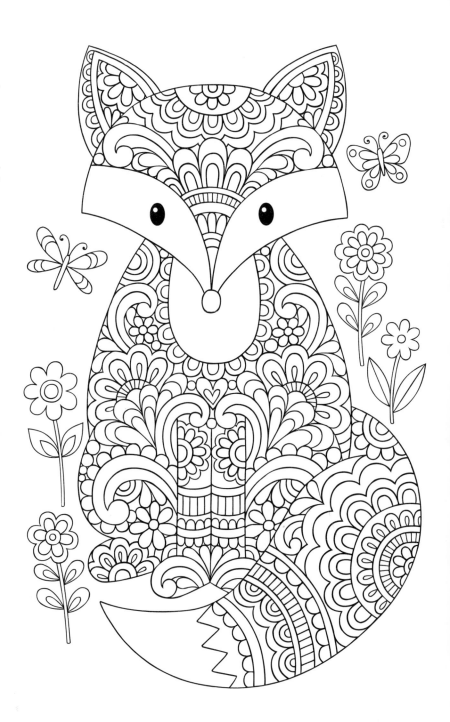

The moments of happiness we enjoy
take us by surprise. It is not that we seize them,
but that they seize us.

—Ashley Montagu

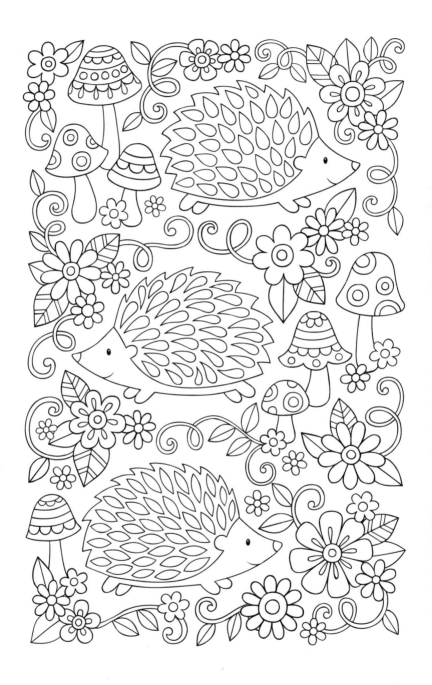

A smile is happiness you'll find
right under your nose.

—Tom Wilson

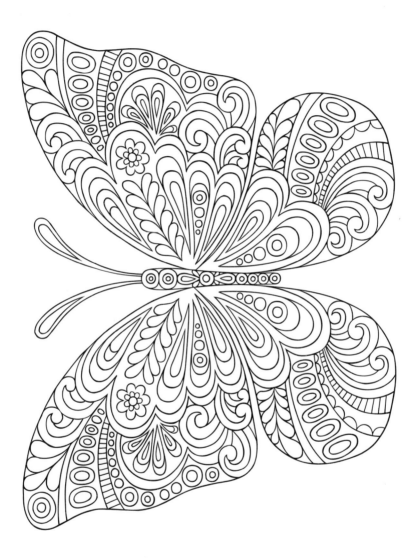

Happiness is a butterfly,
which when pursued,
is always just beyond your
grasp, but which,
if you will sit down quietly,
may alight upon you.

—Nathaniel Hawthorne

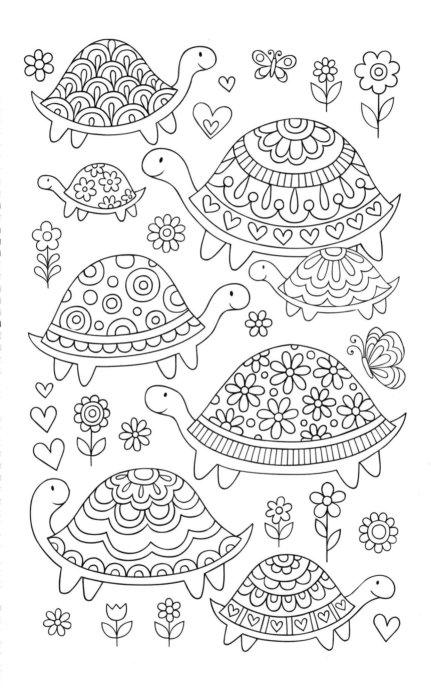

A warm smile is the universal language of kindness.

—William Arthur Ward

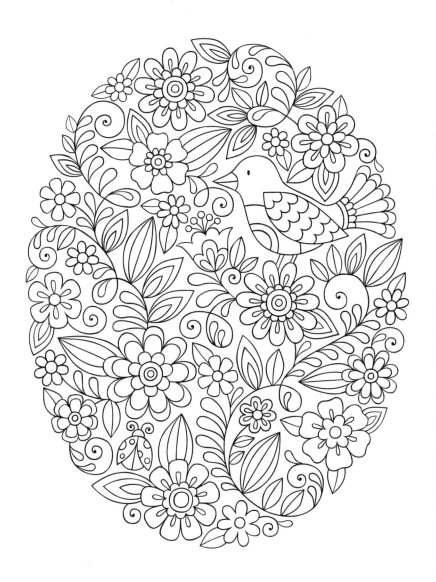

True happiness comes from the
joy of deeds well done, the zest of
creating things new.

—Antoine de Saint-Exupery

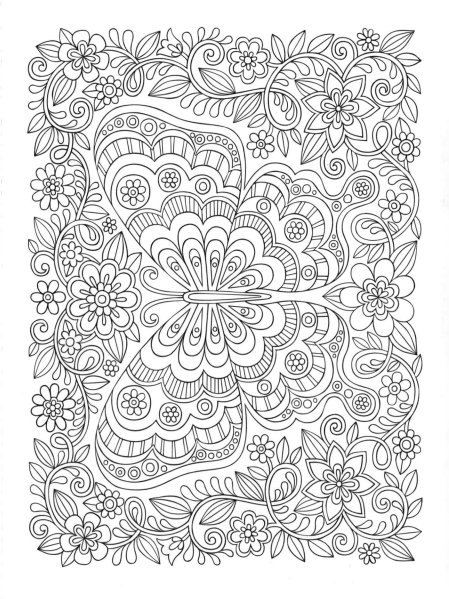

If you smile when no one else is around,
you really mean it.

—Andy Rooney

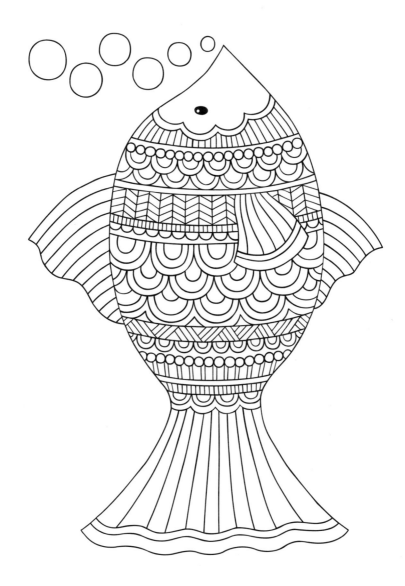

Be silly, be honest, be kind.

—Ralph Waldo Emerson

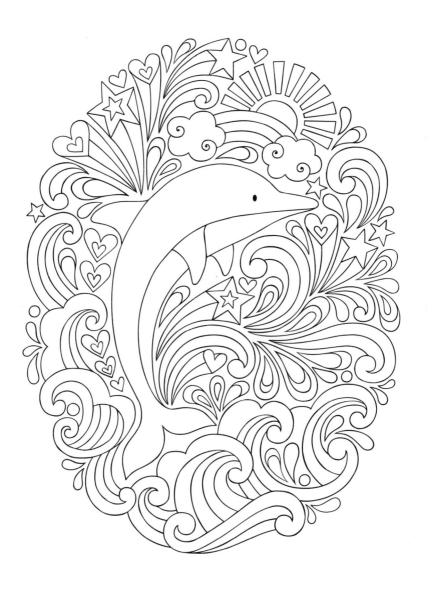

Kindness has a beautiful way of reaching down
into a weary heart and making it shine
like the rising sun.

—Unknown

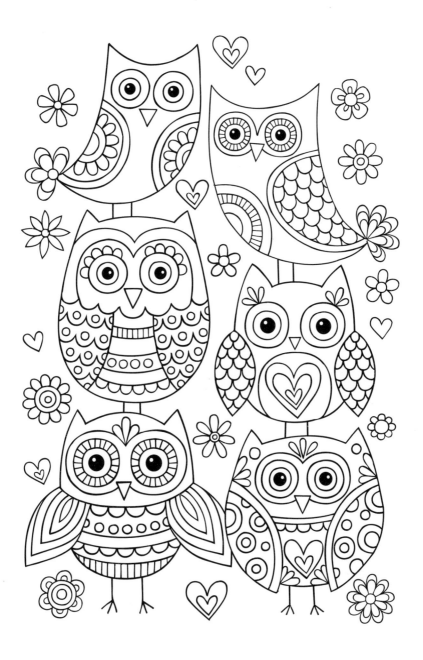

There is a certain happiness
in being silly and ridiculous.

—Unknown

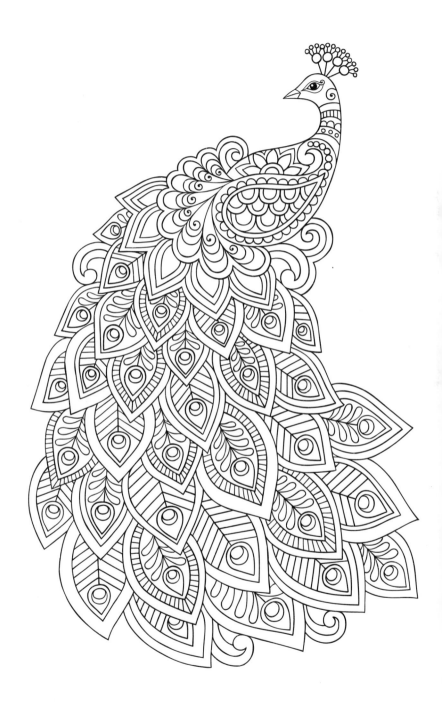

You must give everything to make your life as beautiful as the dreams that dance in your imagination.

—Roman Payne

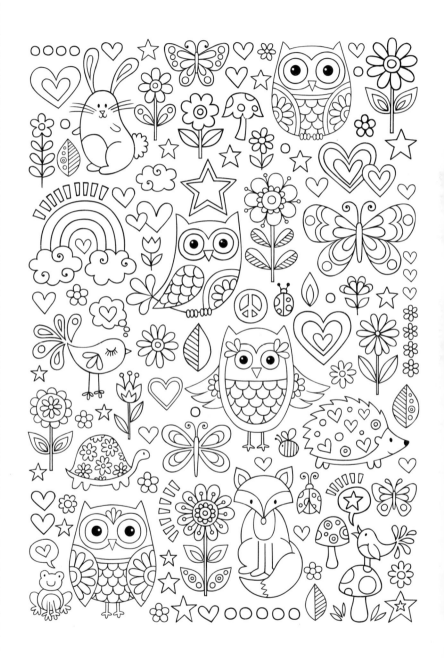

The most important thing is to enjoy your life—
to be happy—it's all that matters.

—Audrey Hepburn

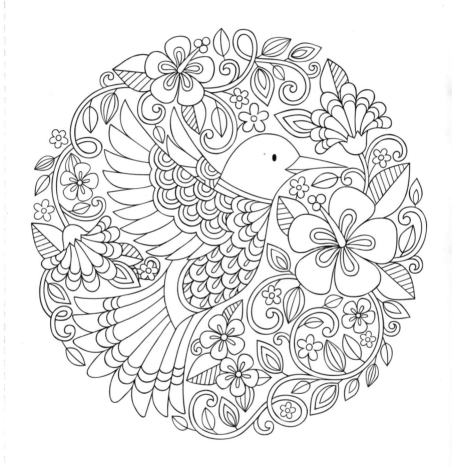

Kindness costs nothing,
yet it is a most precious gift.

—Unknown

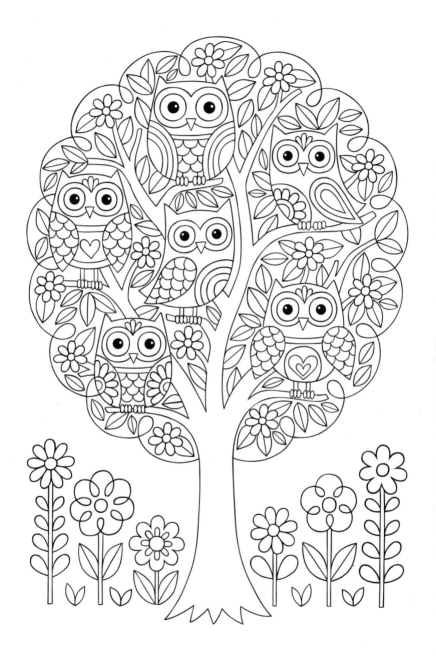

Happiness doesn't result from what we get,
but from what we give.

—Unknown